Bob Ross®

A JOURNAL

RP STUDIO

PHILADELPHIA

Hachette Book Group supports the right to free expression and the value of copyright. The purpose of copyright is to encourage writers and artists to produce the creative works that enrich our culture.

RP Studio
Hachette Book Group
1290 Avenue of the Americas, New York, NY 10104
www.runningpress.com
@Running_Press

Printed in China

First Edition: 09/18

Published by RP Studio, an imprint of Perseus Books, LLC,
a subsidiary of Hachette Book Group, Inc. The RP Studio name and logo
is a trademark of the Hachette Book Group.

The publisher is not responsible for websites (or their content)
that are not owned by the publisher.

Design by Ashley Todd.

ISBN: 978-0-7624-9169-8 (flexibound)

1010

10 9 8 7 6 5 4

"If what you're doing doesn't make you happy, you're doing the wrong thing."

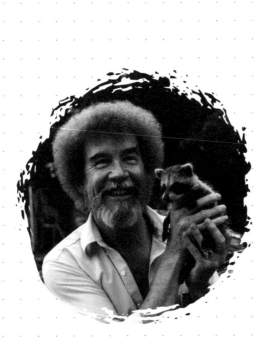

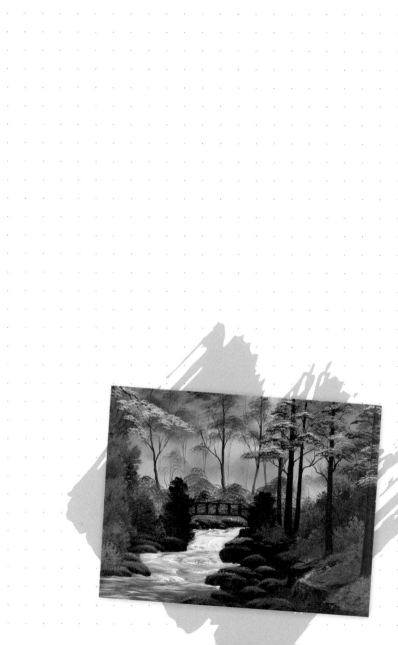

"Don't be afraid to scrape the paint
off and do it again. This is the way you learn:
trial and error, over and over, repetition."

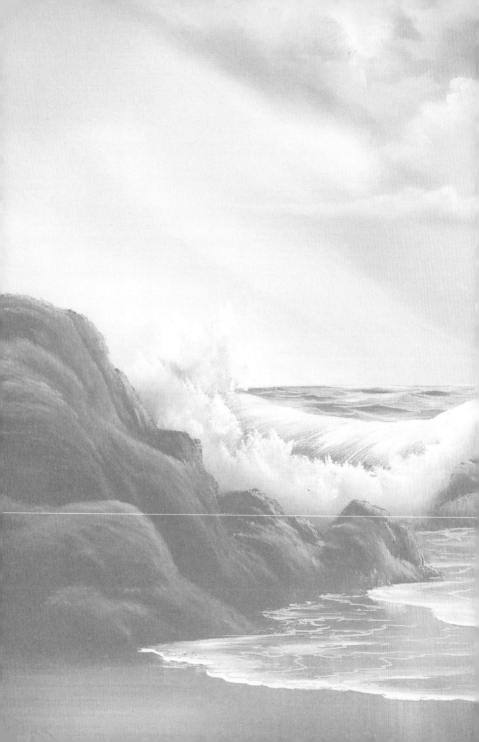

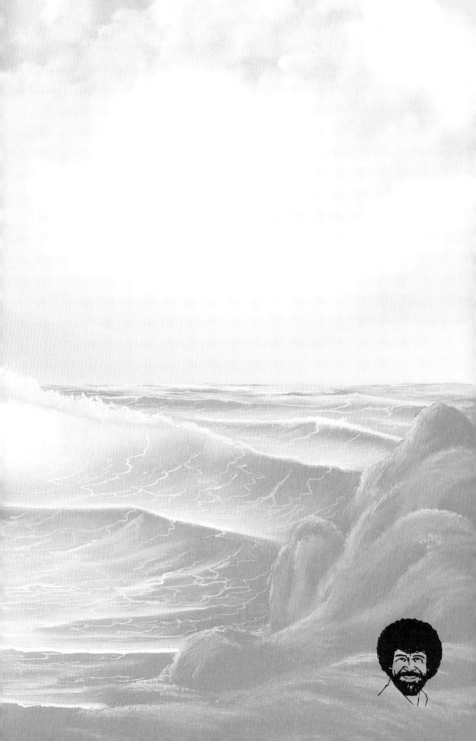

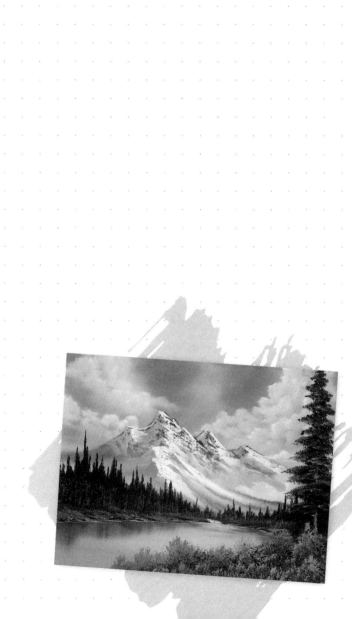

*"You can create beautiful things,
but you have to see them in your mind first."*

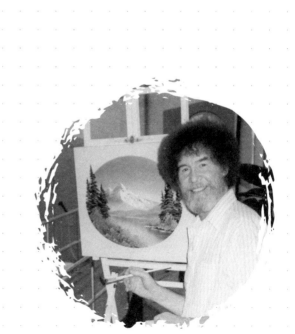

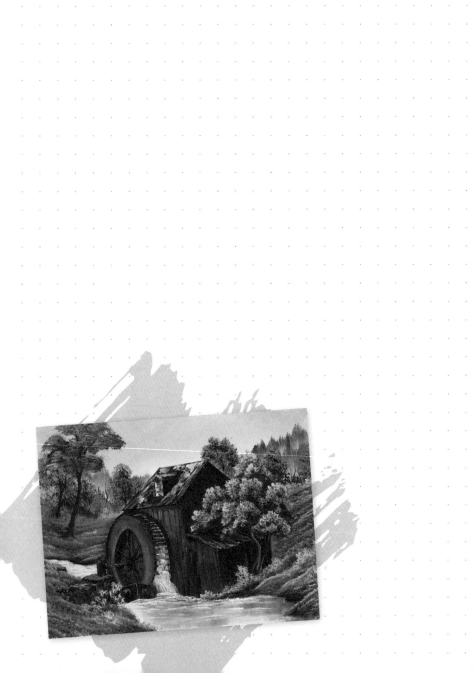

> *"Anything we don't like, we'll turn it into a happy little tree or something; we don't make mistakes, we just have happy accidents."*

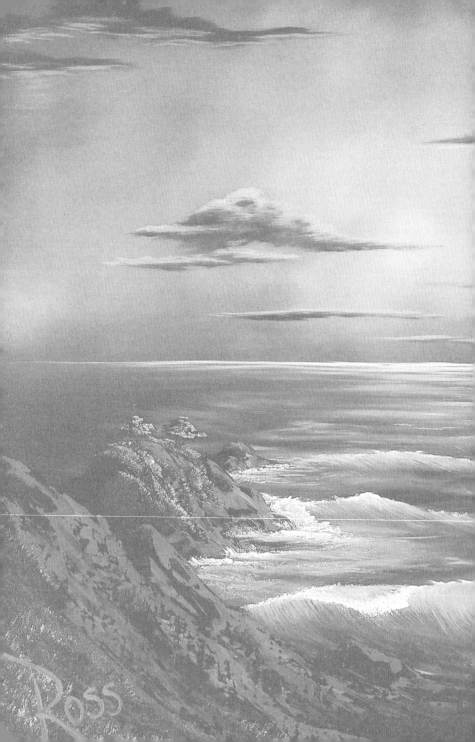

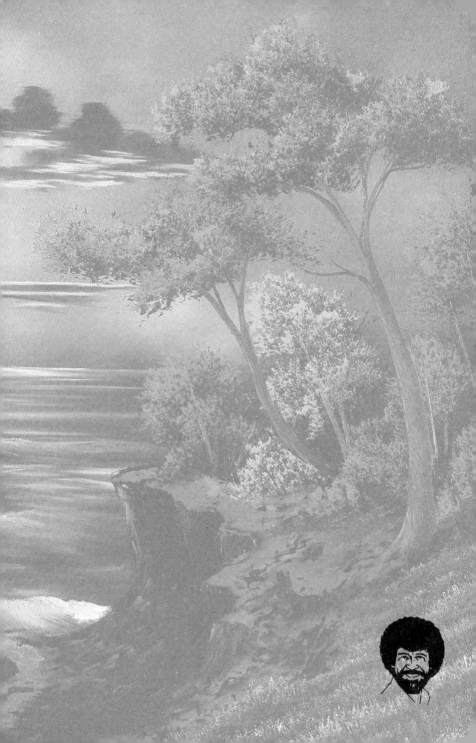

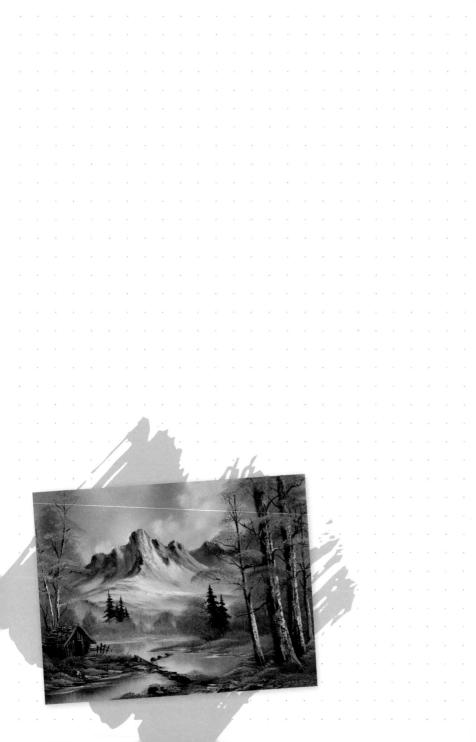

*"If we all painted the same way,
what a boring world it would be."*

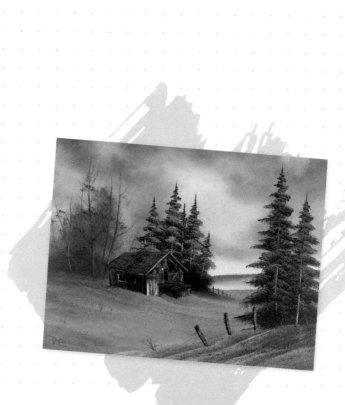

"If it's not what you want, stop
and change it. Don't just keep going
and expect it will get better."

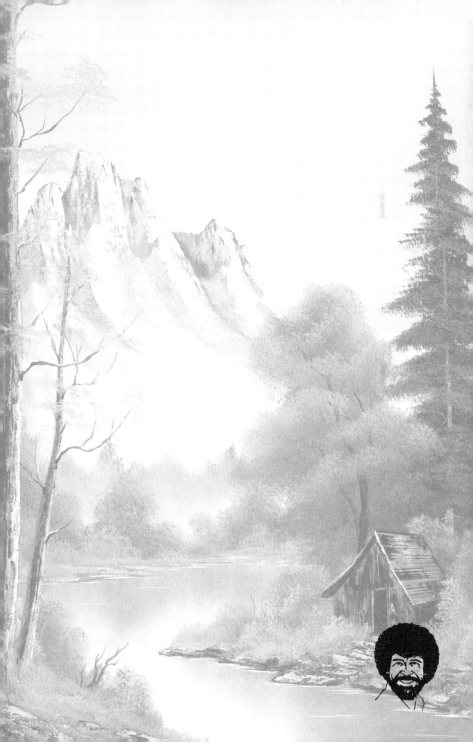

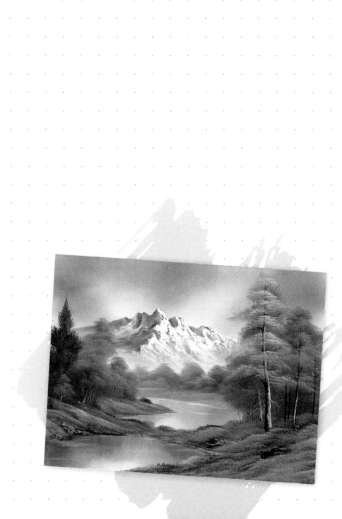

"The secret to doing anything is believing that you can do it. Anything that you believe you can do strong enough, you can do. Anything. As long as you believe."

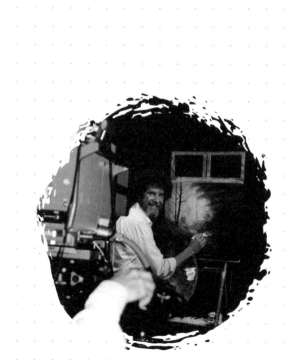

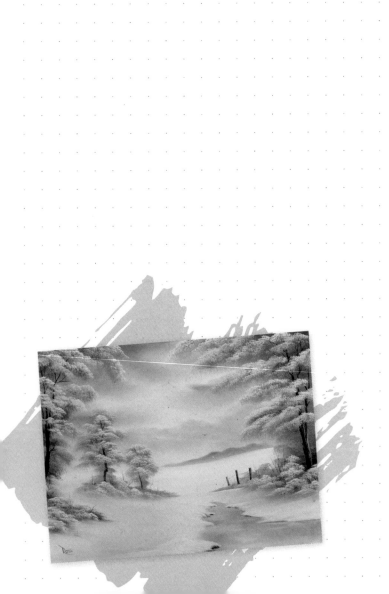

*"Put light against light–you have nothing.
Put dark against dark–you have nothing.
It's the contrast of light and dark that
each gives the other one meaning."*

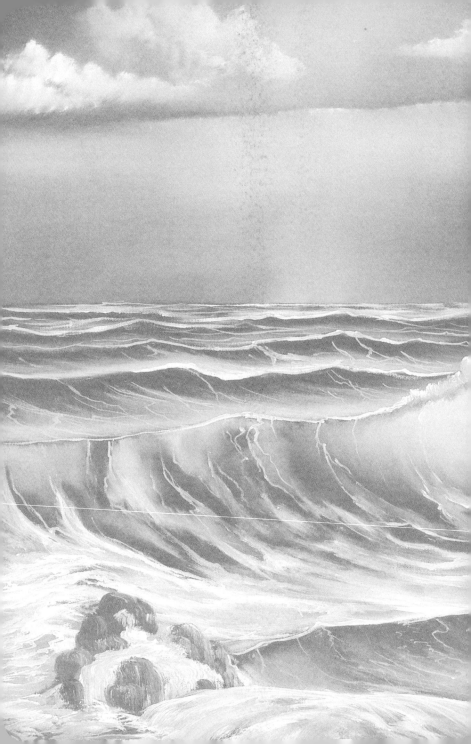

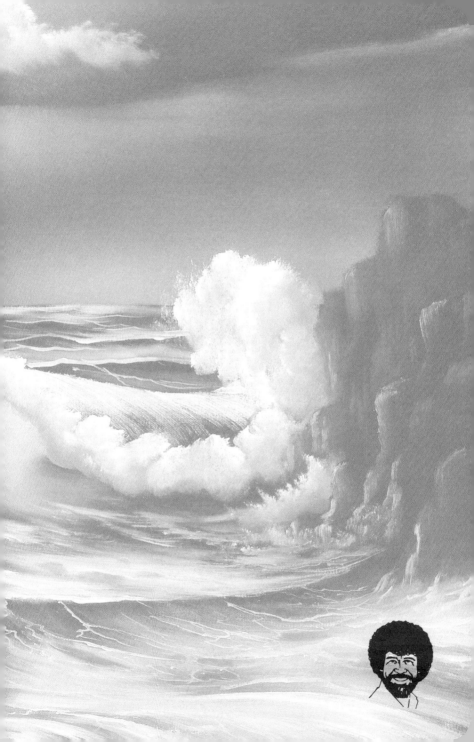

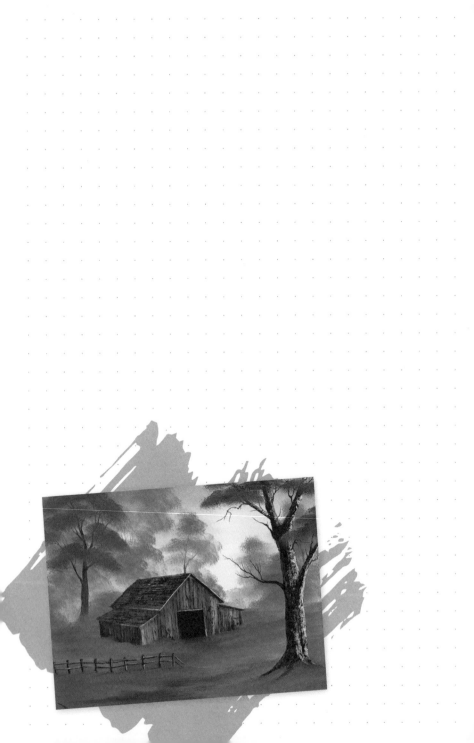

"It's the imperfections that make something beautiful. That's what makes it different and unique from everything else."

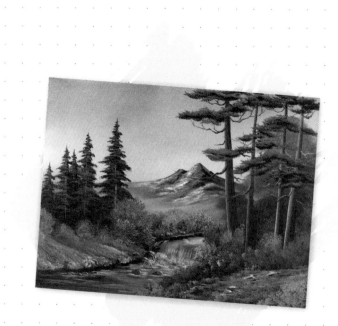

"*All it takes is just a little change of perspective and you begin to see a whole new world.*"

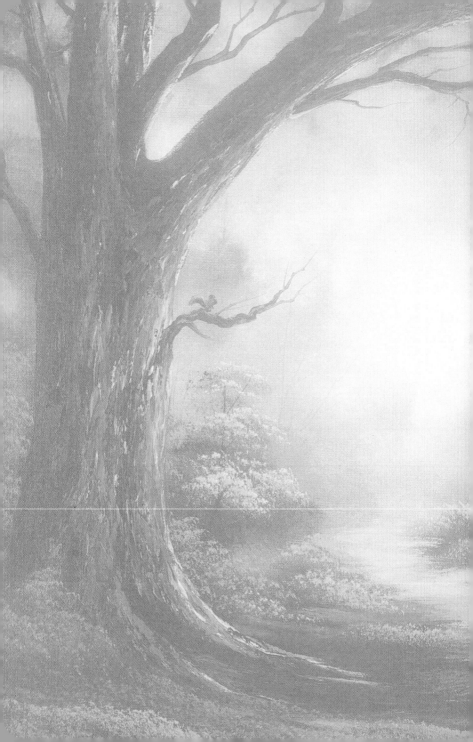

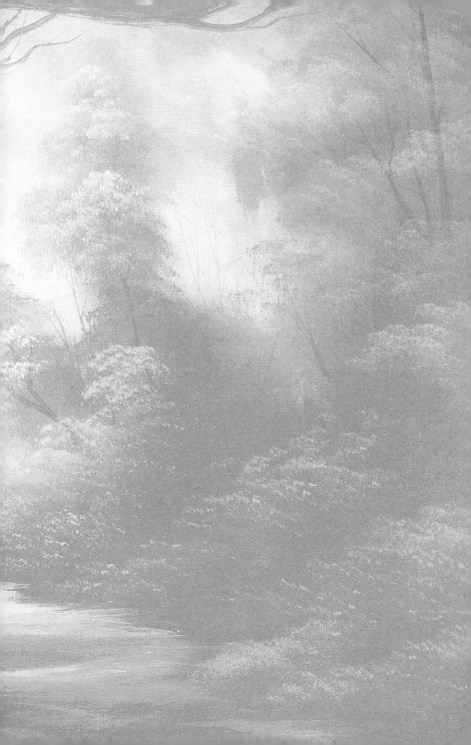

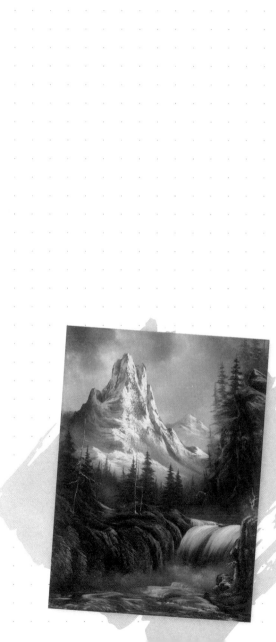

> **"That's when you experience joy–
> when you have no fear."**

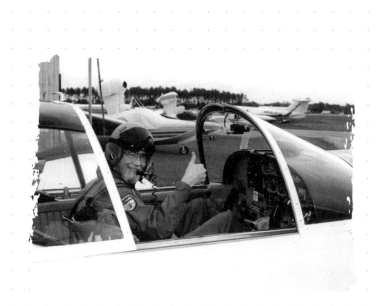

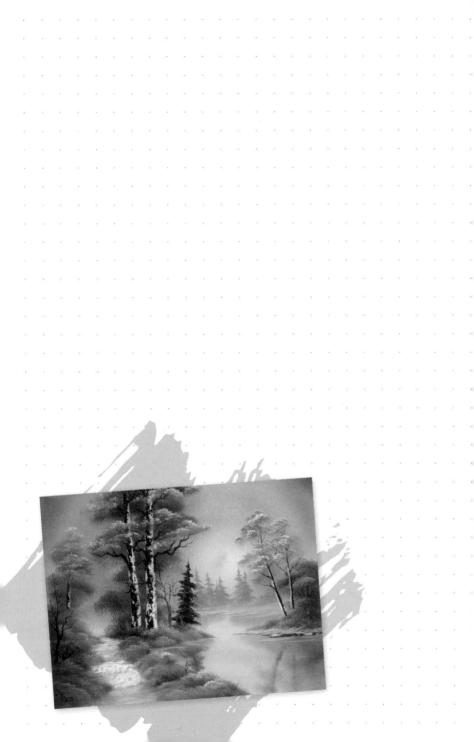

"Friends are the most
important commodity in the world.
Even a tree needs a friend."

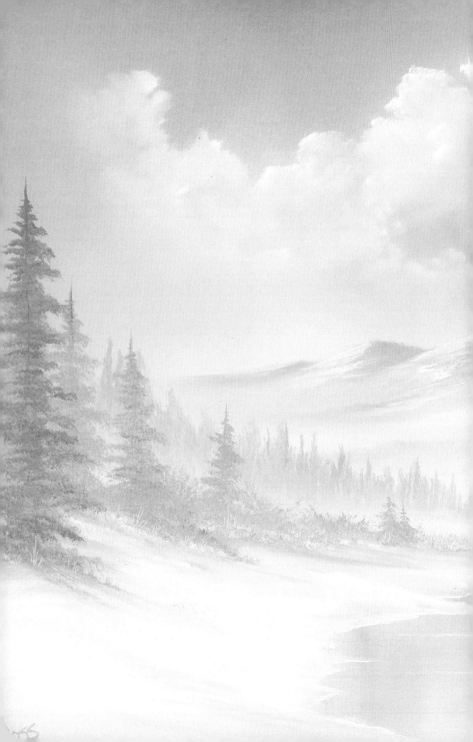

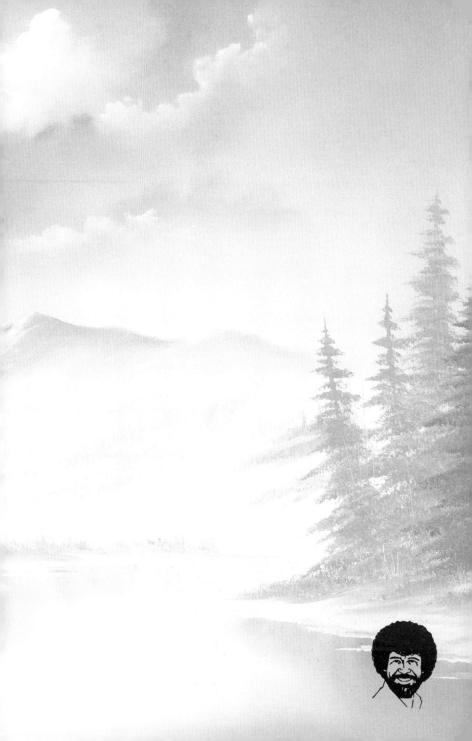

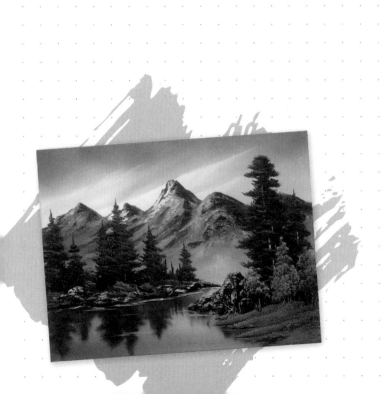

> *"Sometimes you learn more
> from your mistakes than you do
> from your masterpieces."*

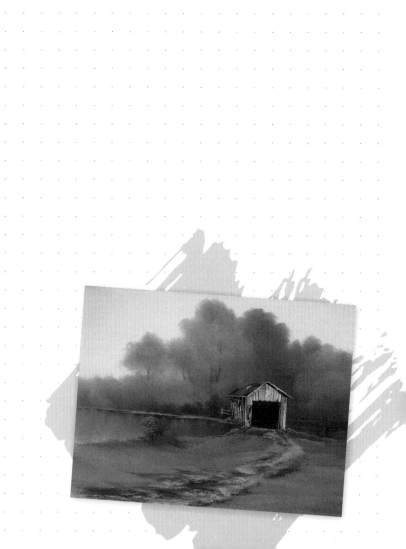

> **"In nature, dead trees are just as normal as live trees."**

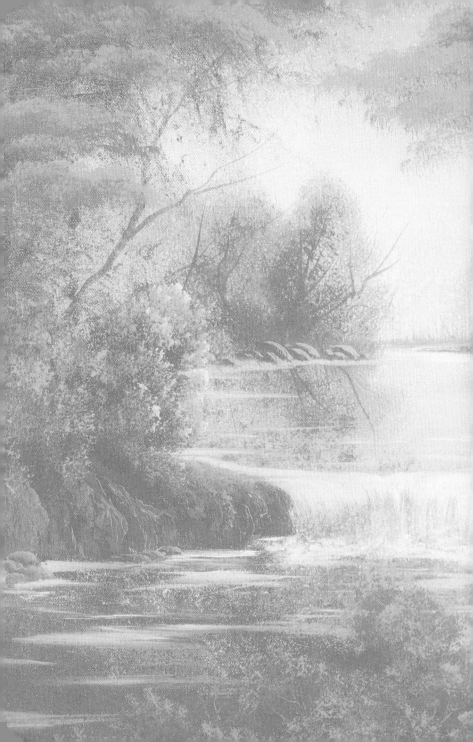

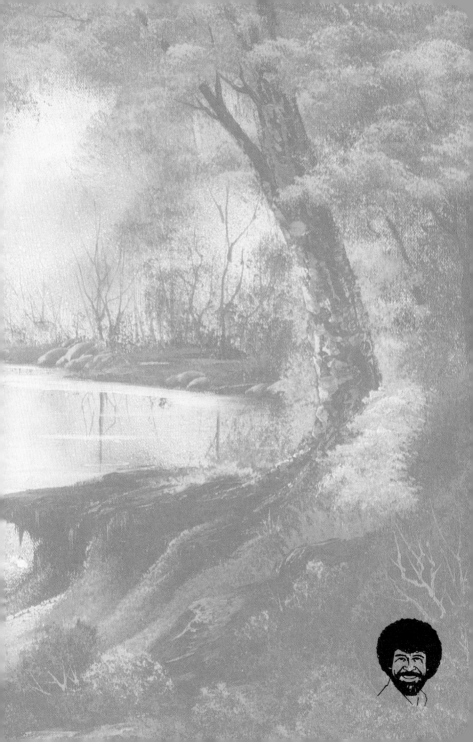

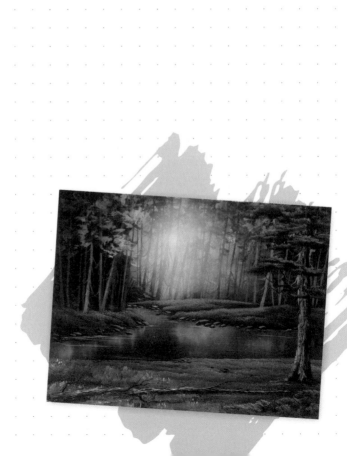

"We each see the world in our own way.
That's what makes it such a special place."

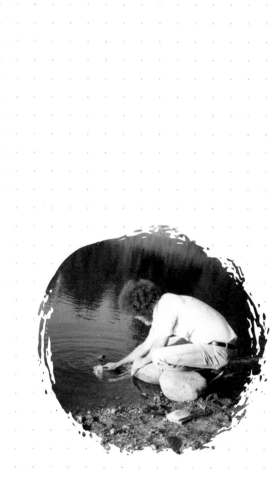

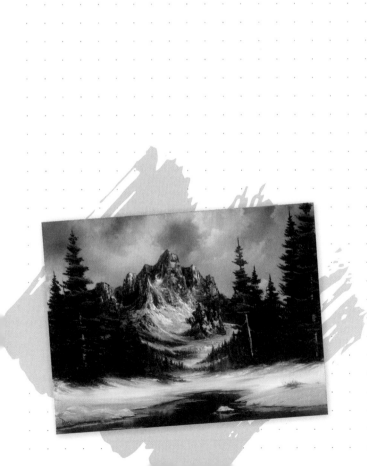

"Every single thing in the world has
its own personality, and it is up to you to
make friends with the little rascals."

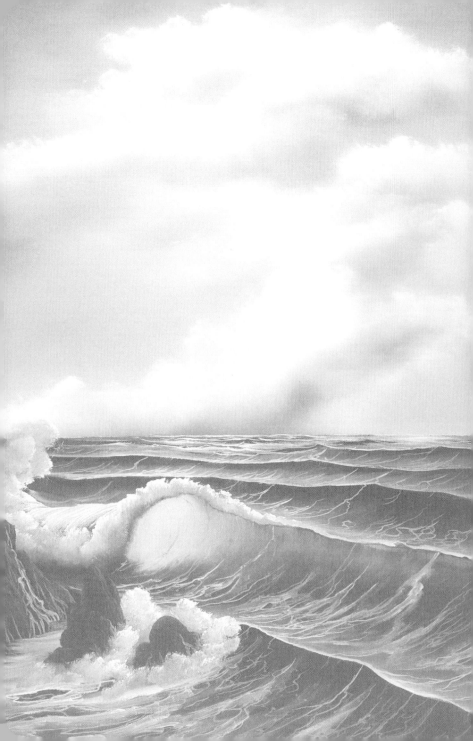

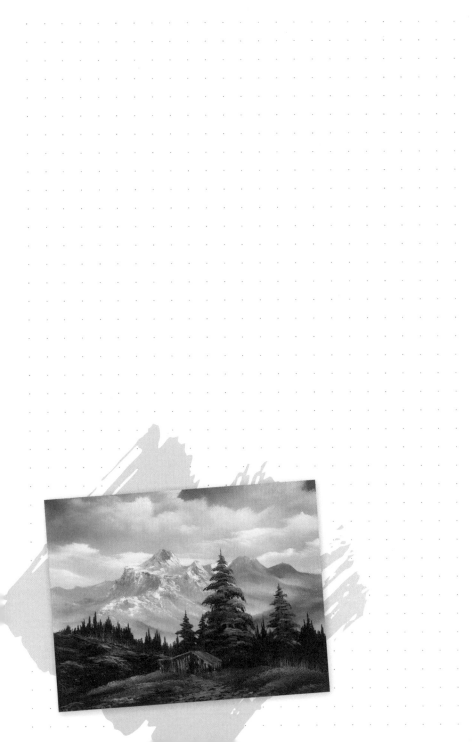

"Just let your imagination go.
You can create all kinds of beautiful
effects, just that easy."

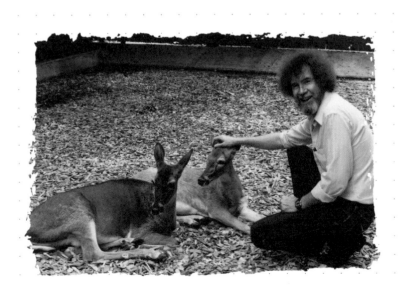

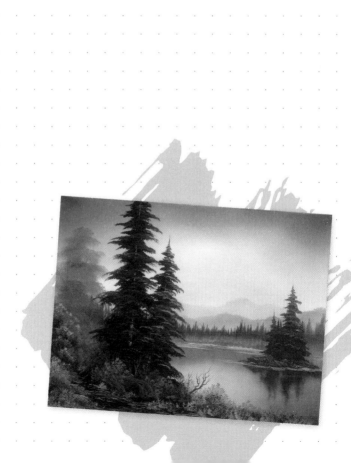

"We have no limits to our world.
We're only limited by our imagination."

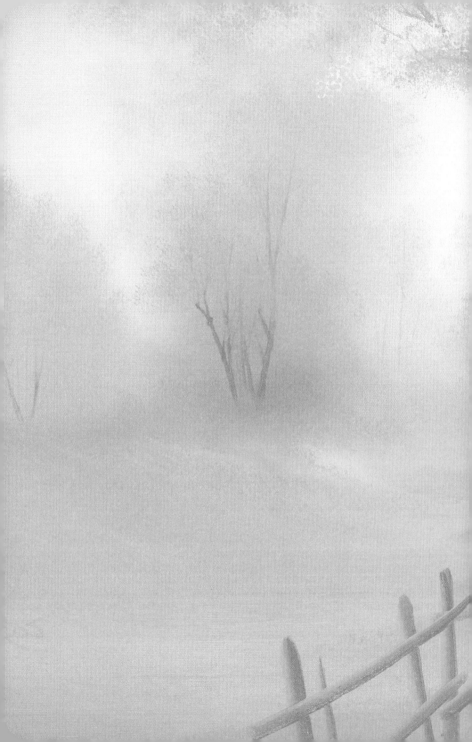

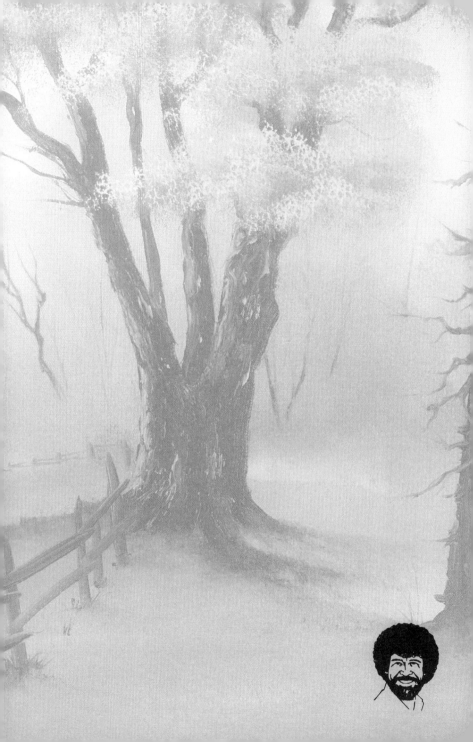

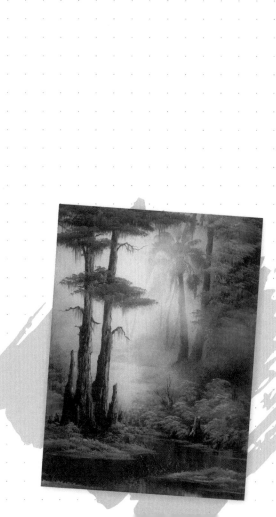

"Talent is a pursued interest. Anything that you're willing to practice, you can do."

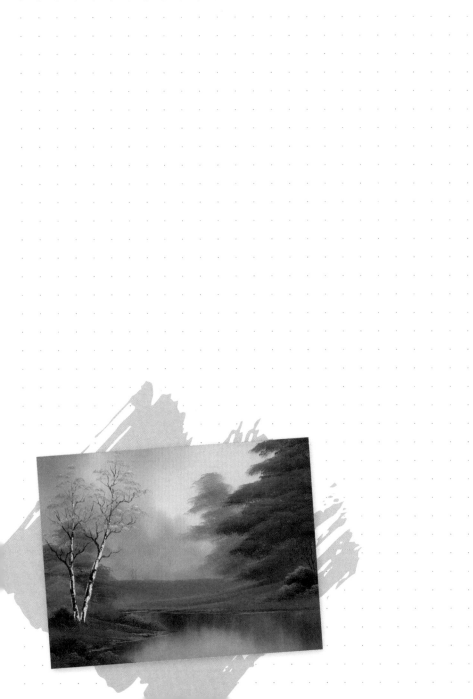

"You'll never believe what you can
do until you get in there and try it."

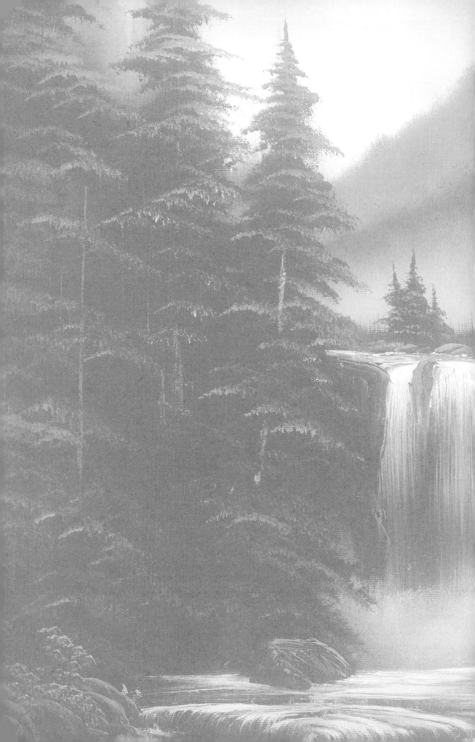

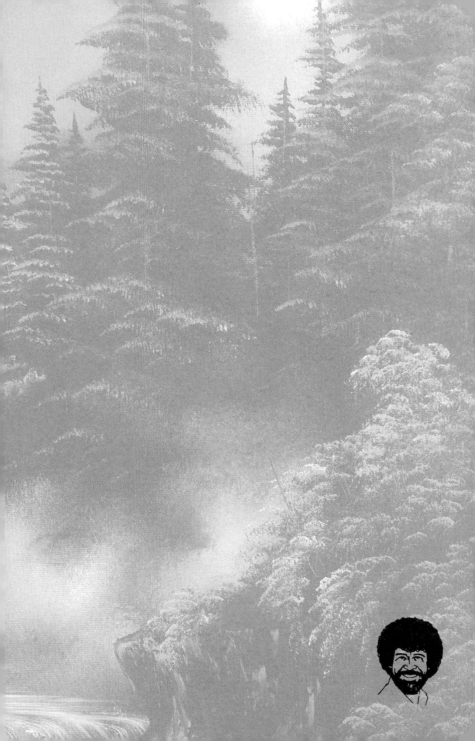

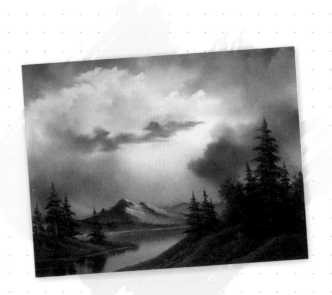

"Exercising the imagination, experimenting with talents, being creative . . . these things, to me, are truly the windows to your soul."